VINT&GE CIRCUS

coloring book for adults

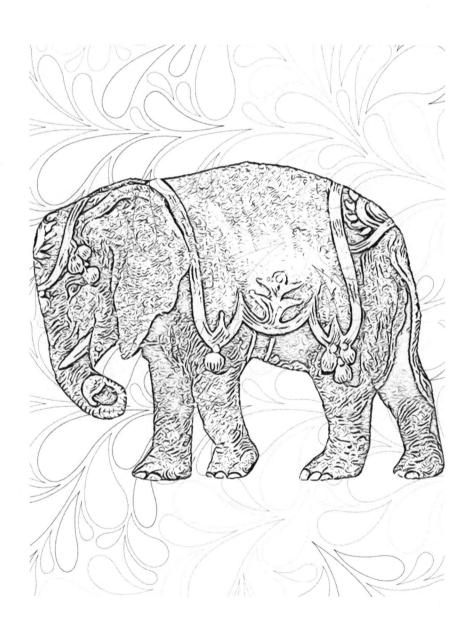

Copyright © 2019 by Color me Vintage

THE CIRCUS GIRL

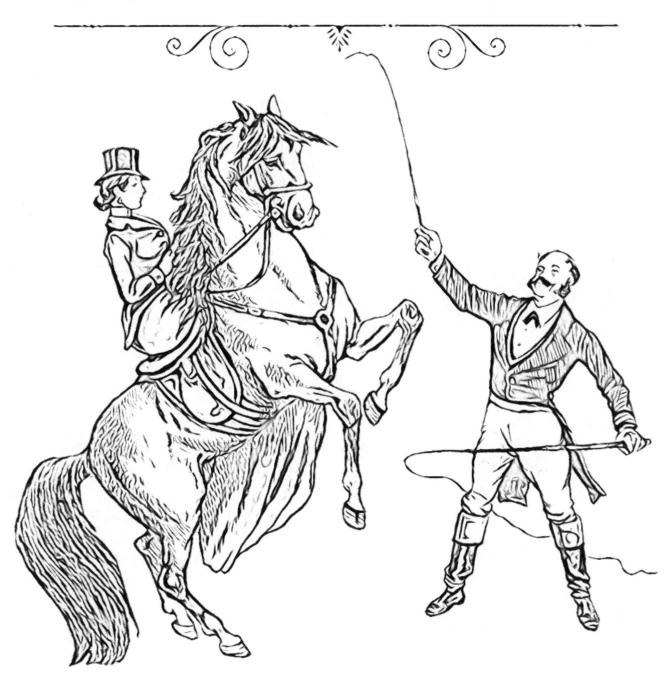

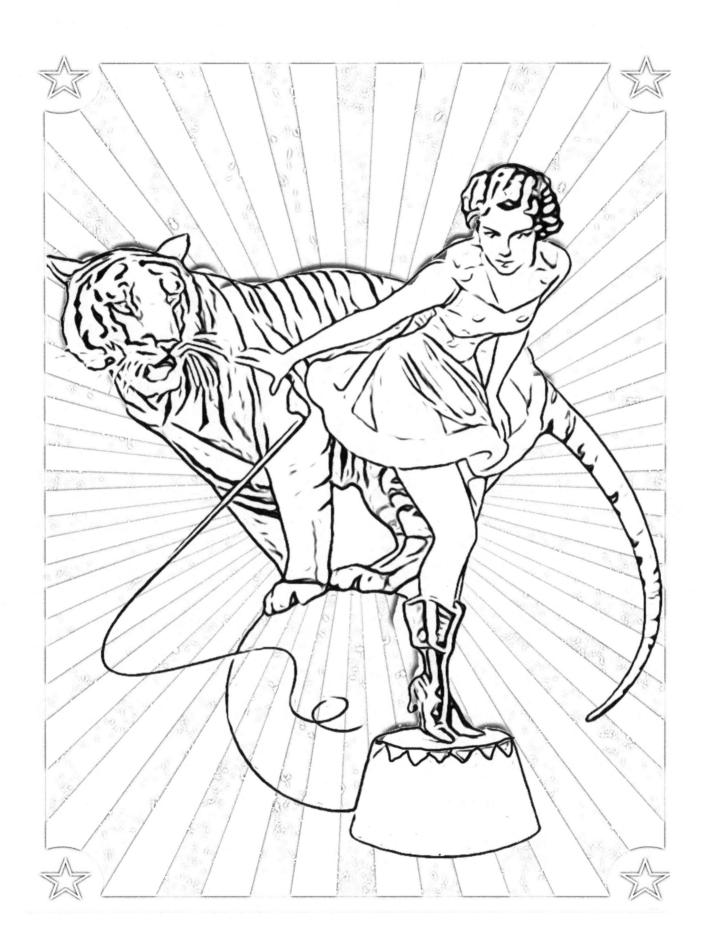

Clyde Colle Bros.

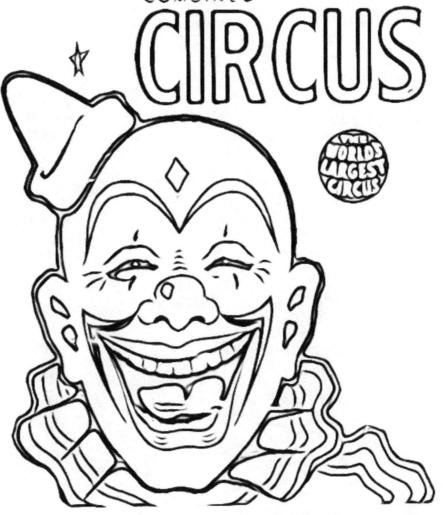

Columbus Park
PERFORMANCES 22

WED. O

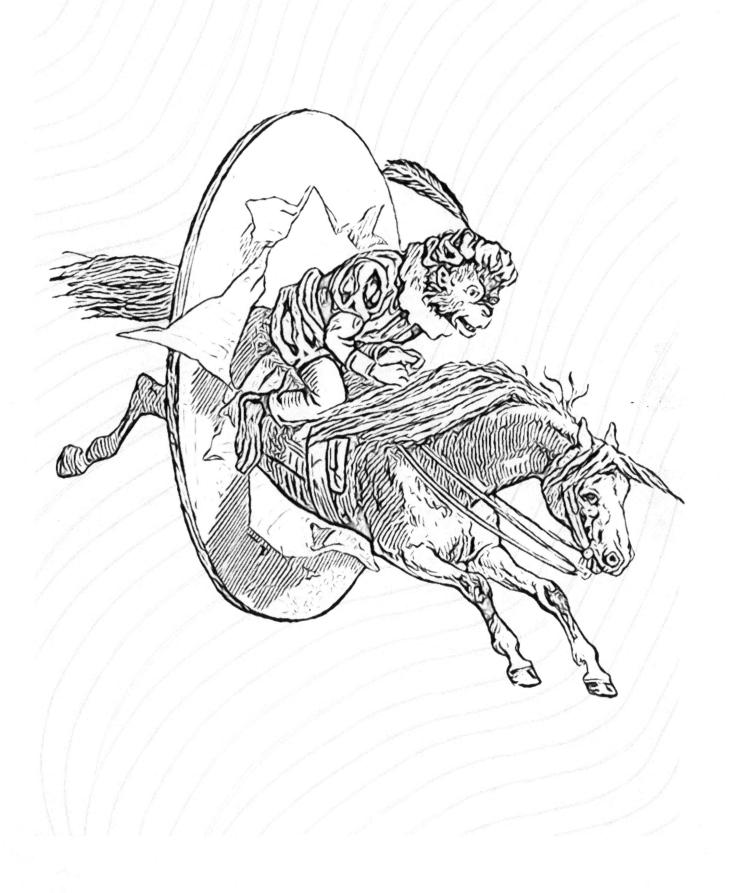

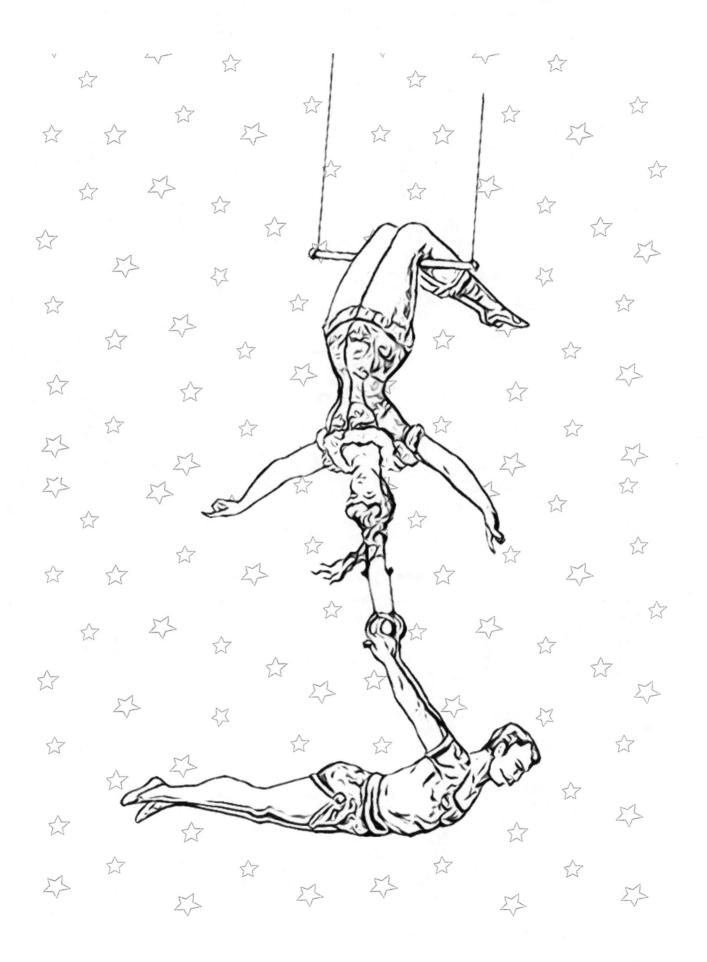

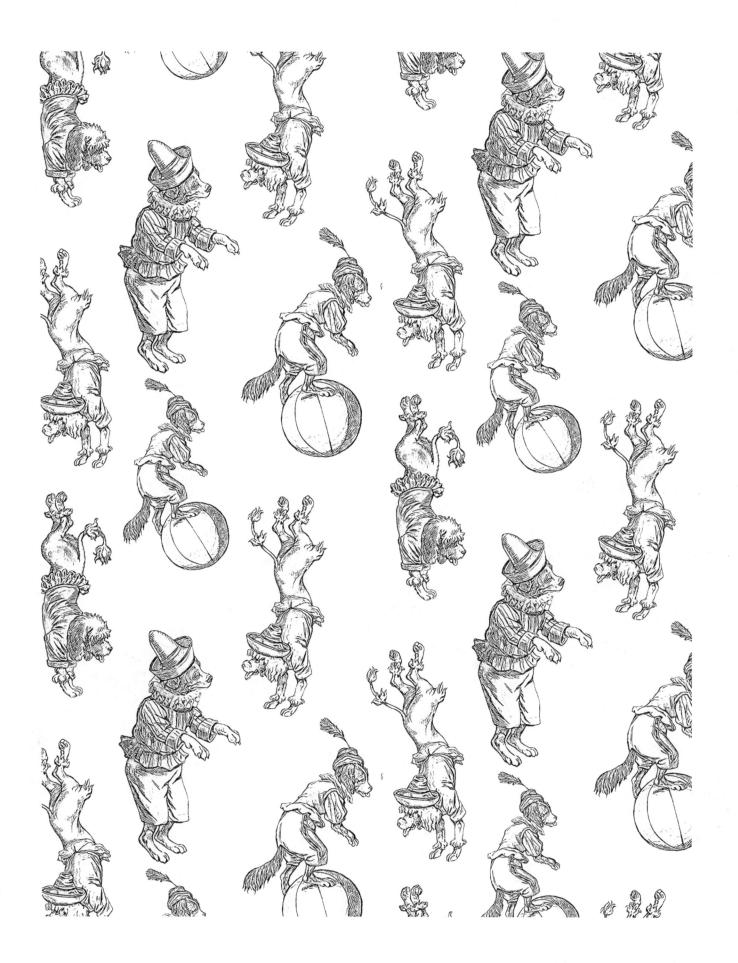

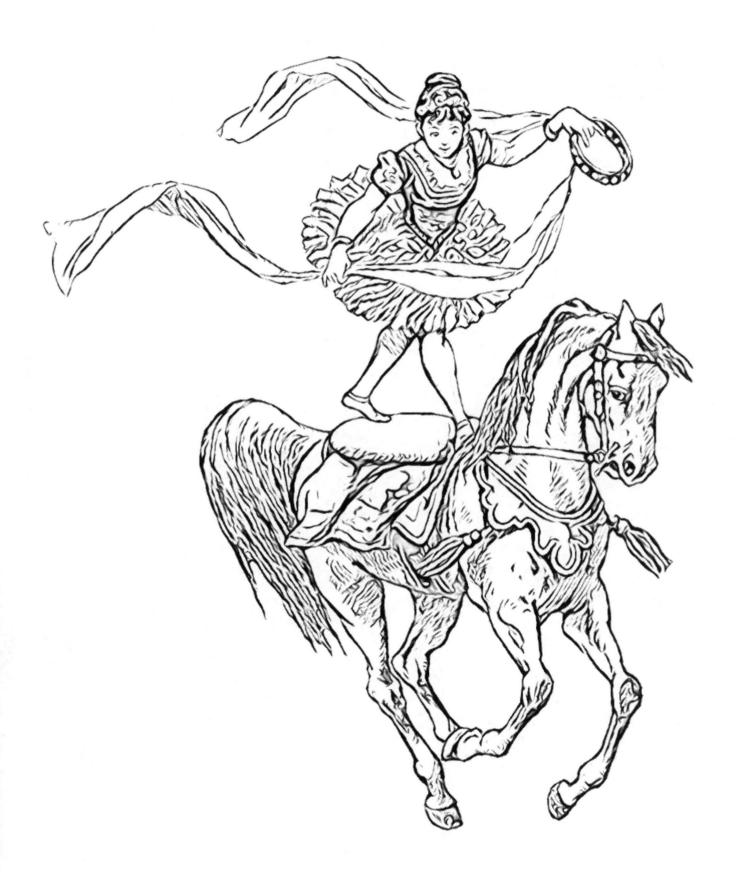

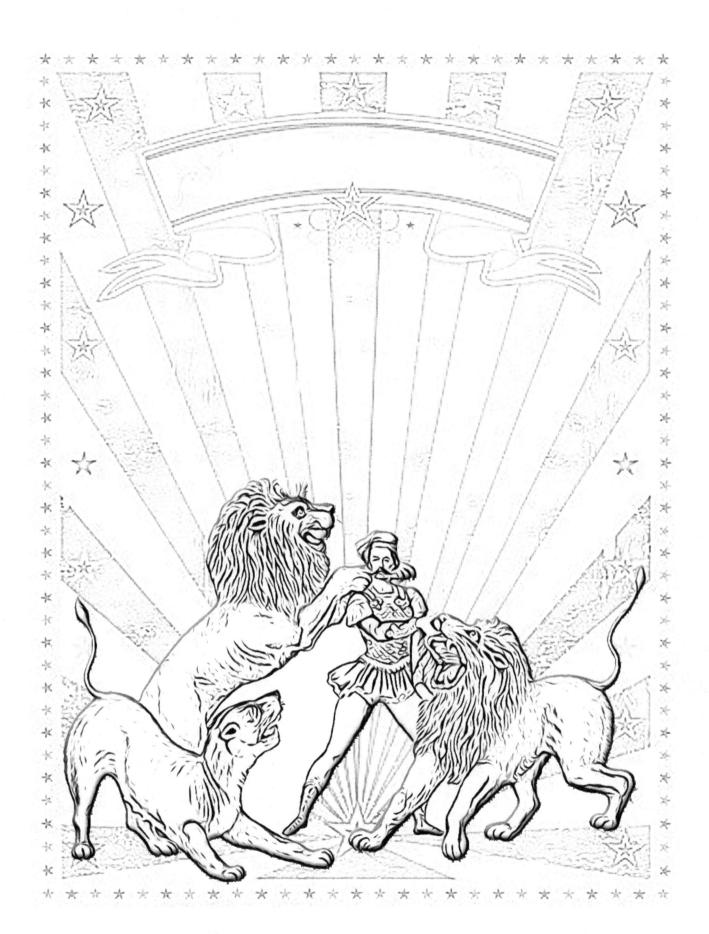

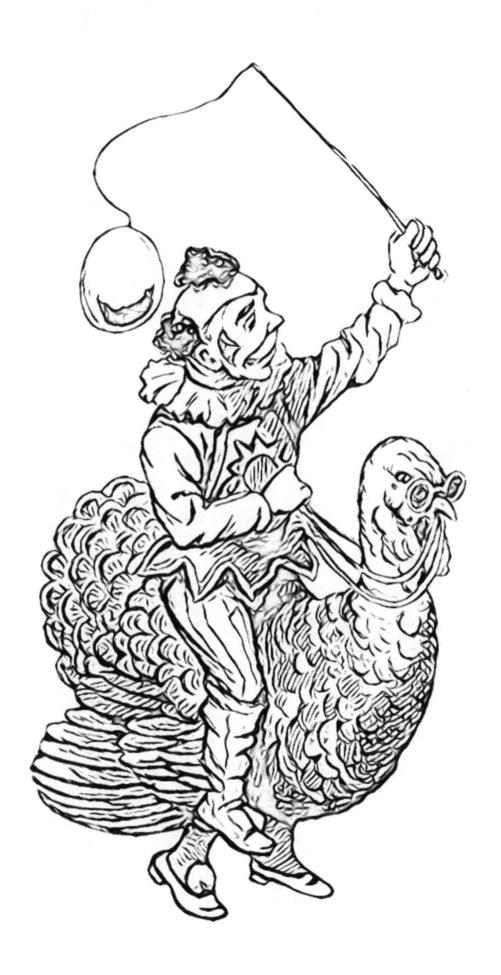

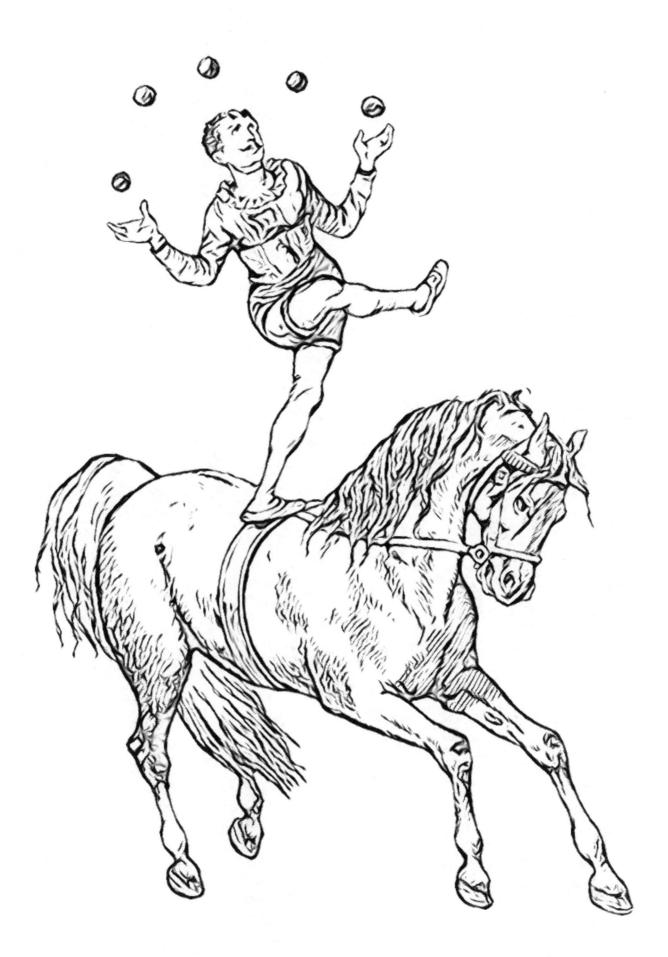

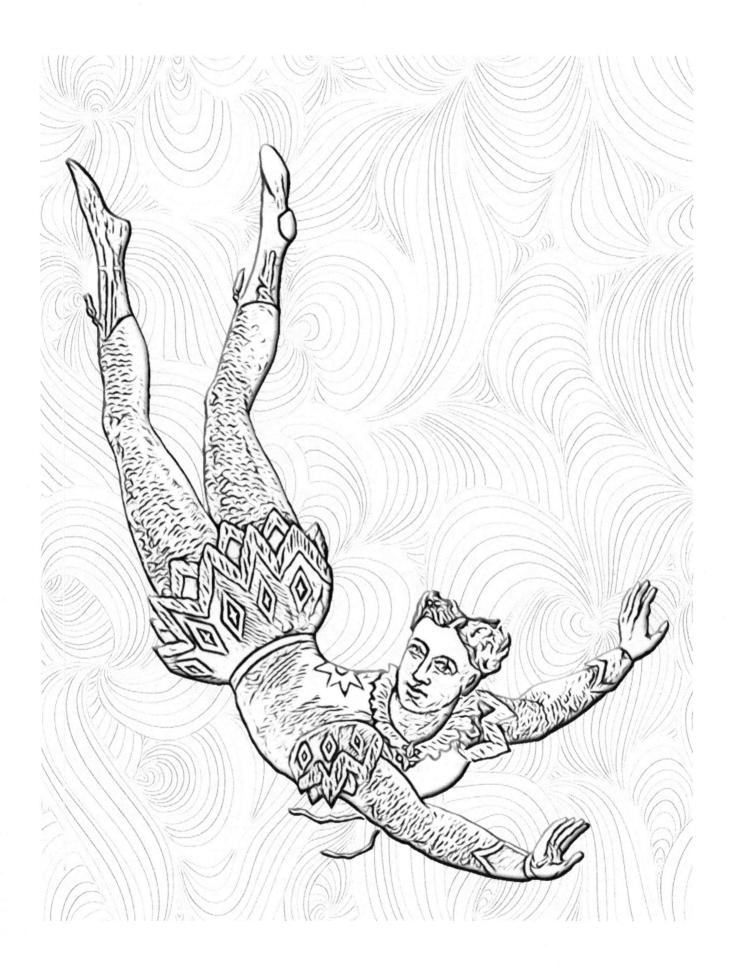

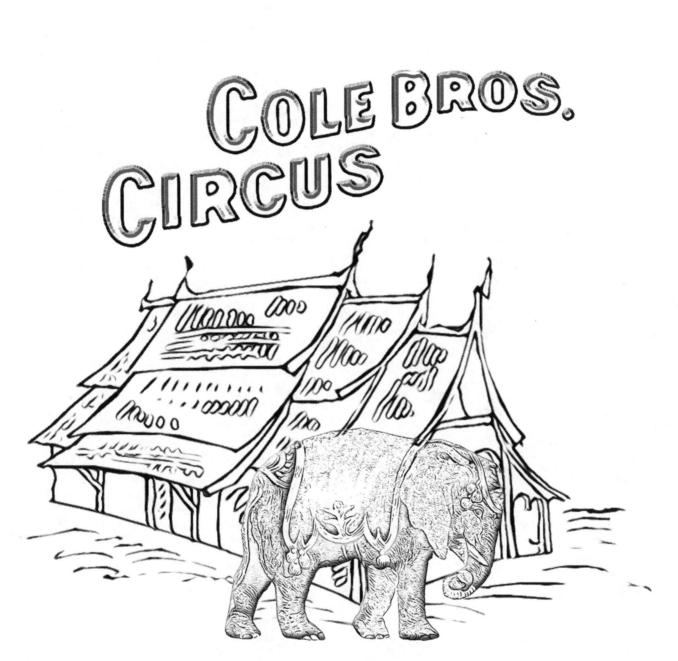

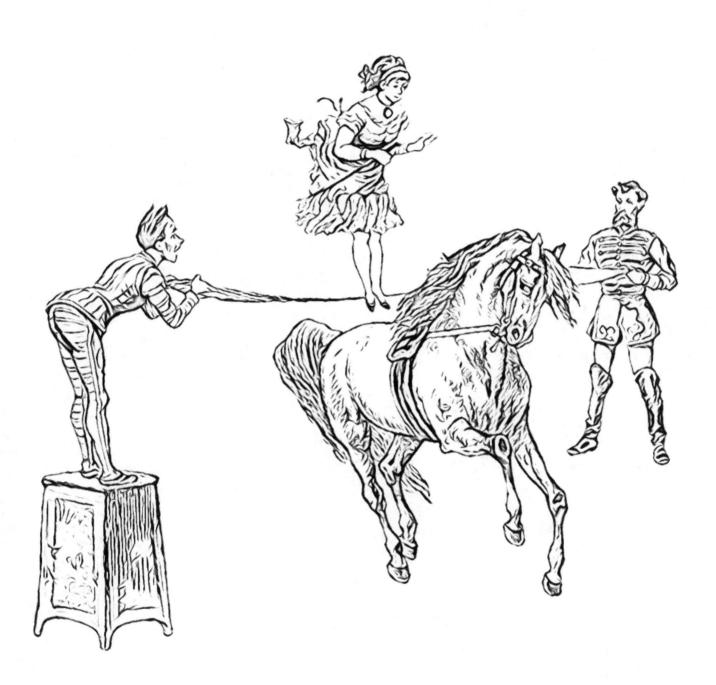

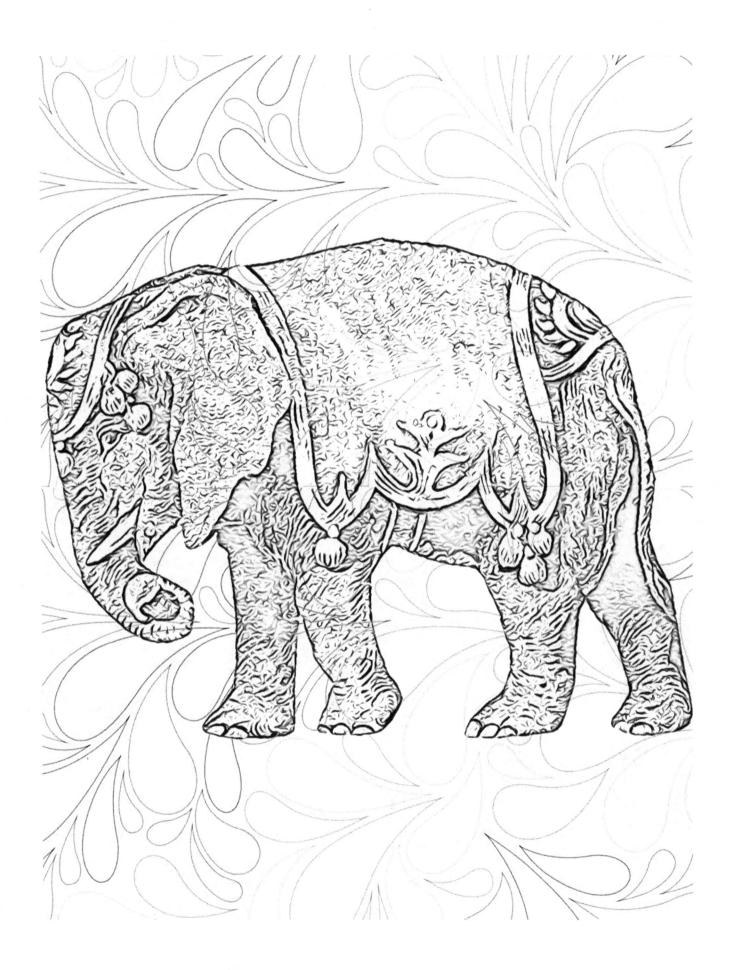

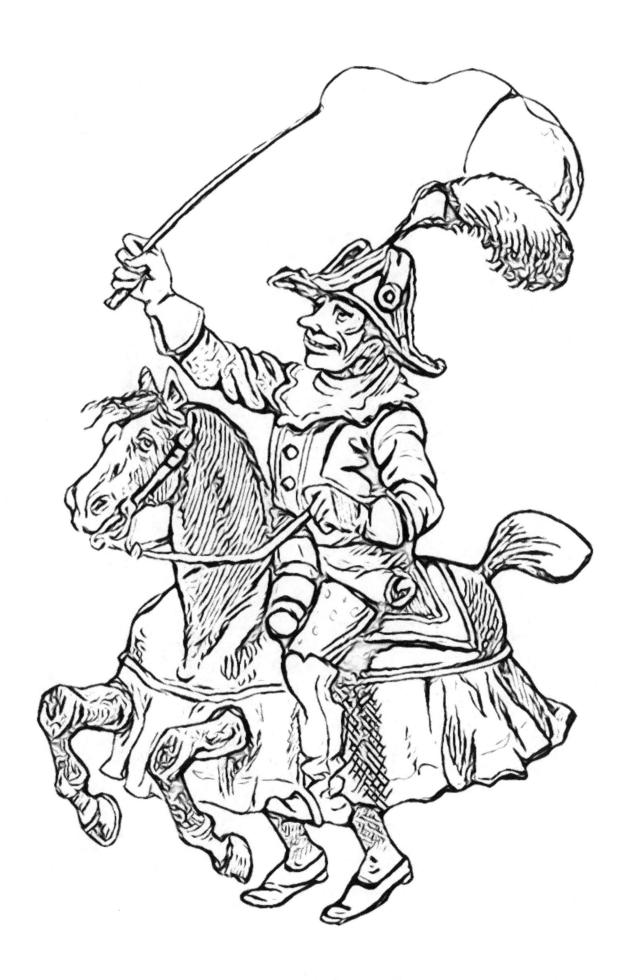

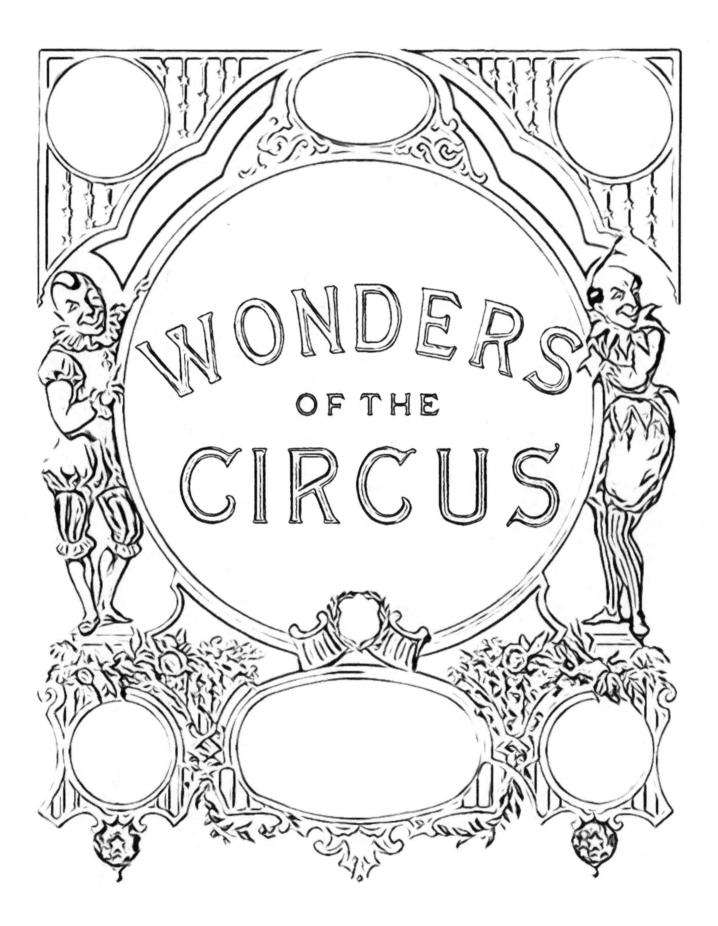

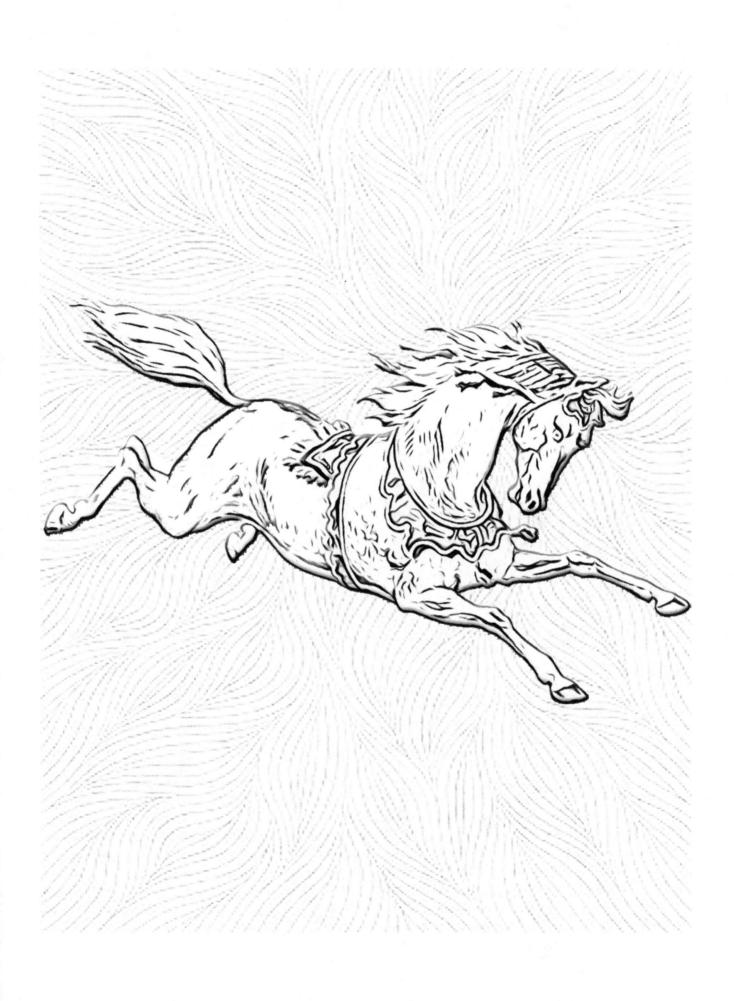

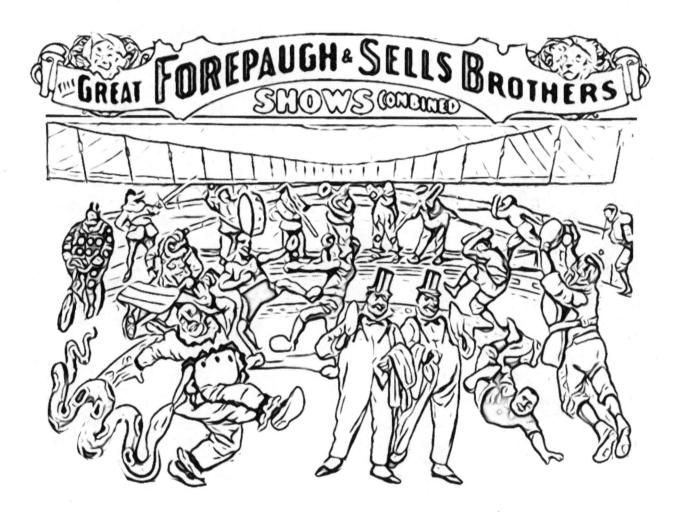

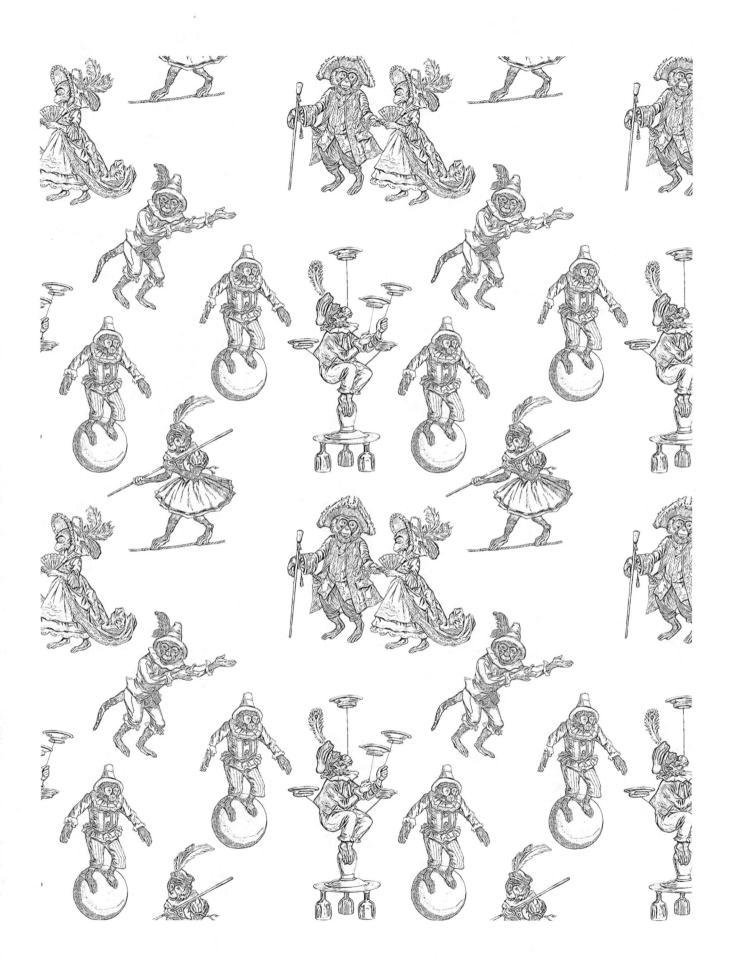

DOWNIE BROS. BIG BRING CIRCUS

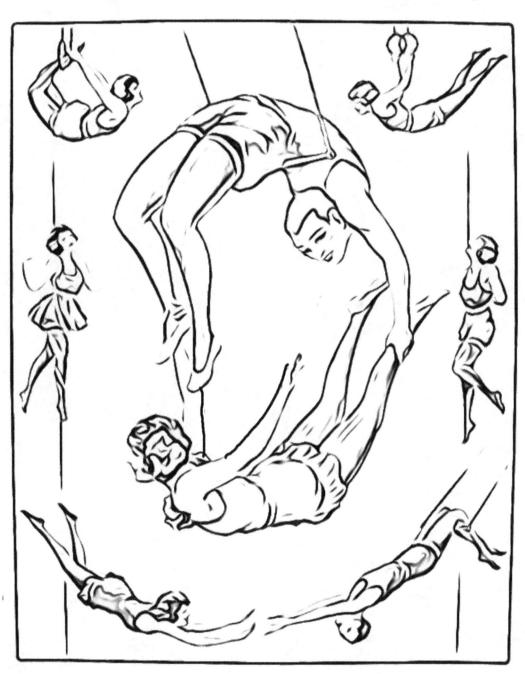

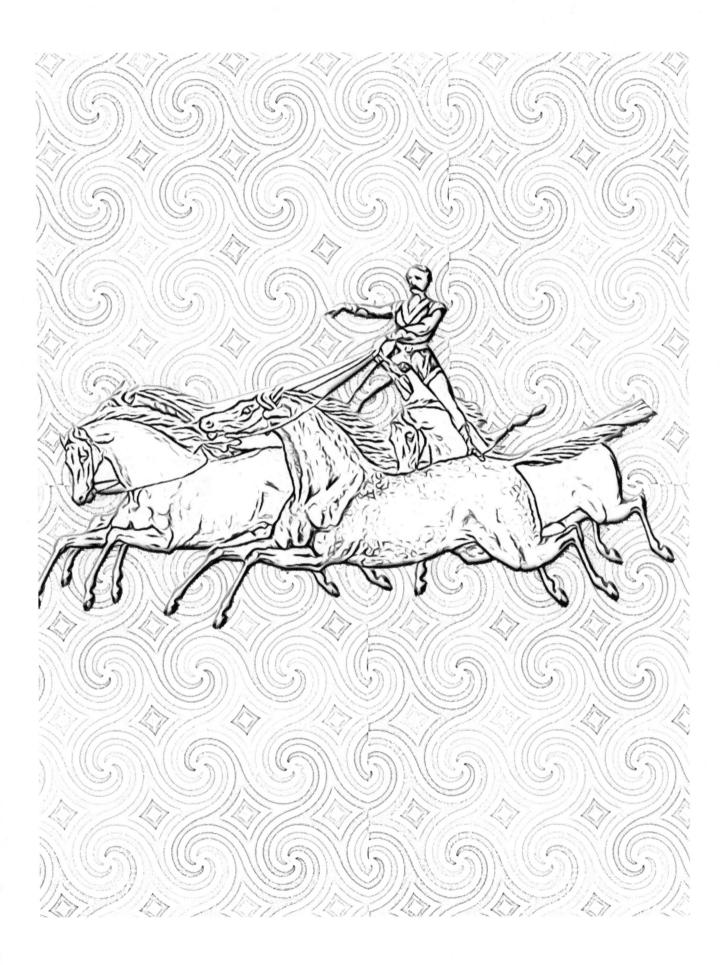

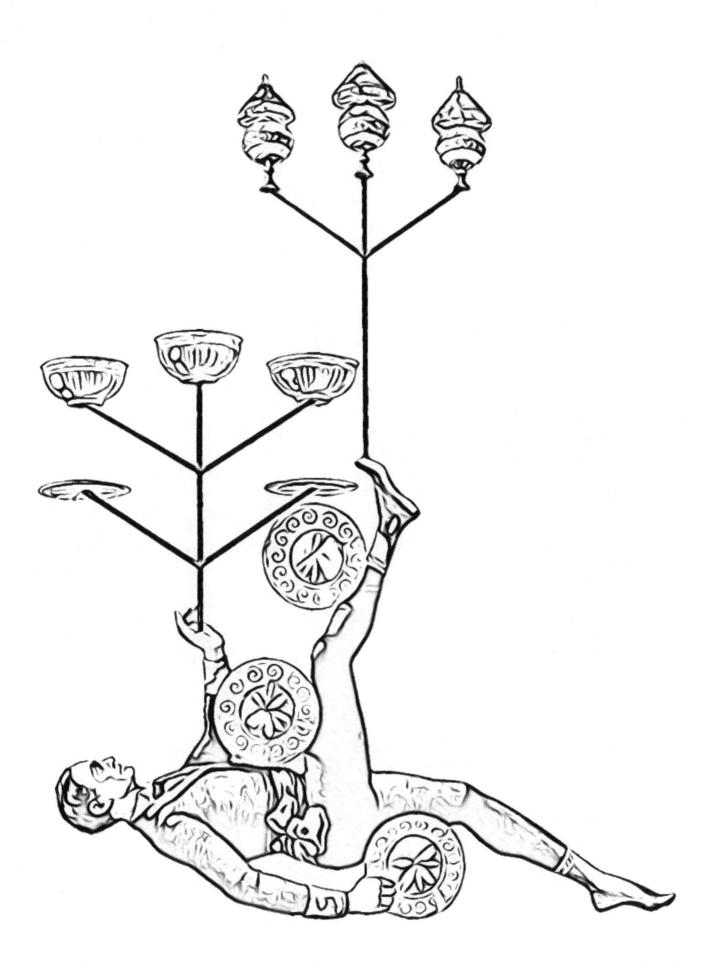

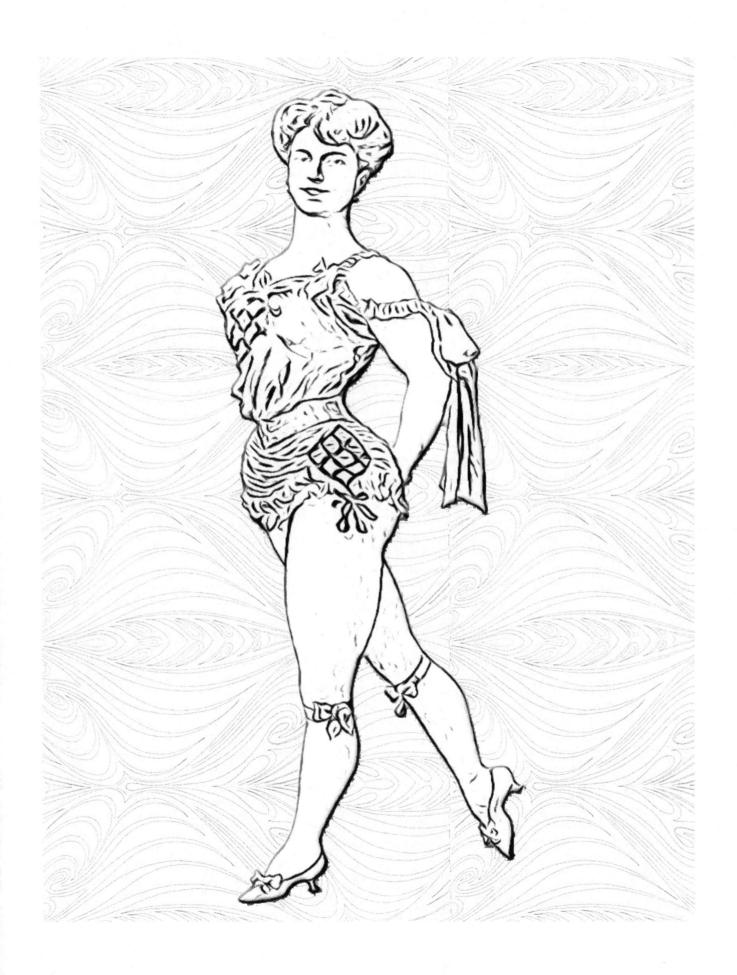

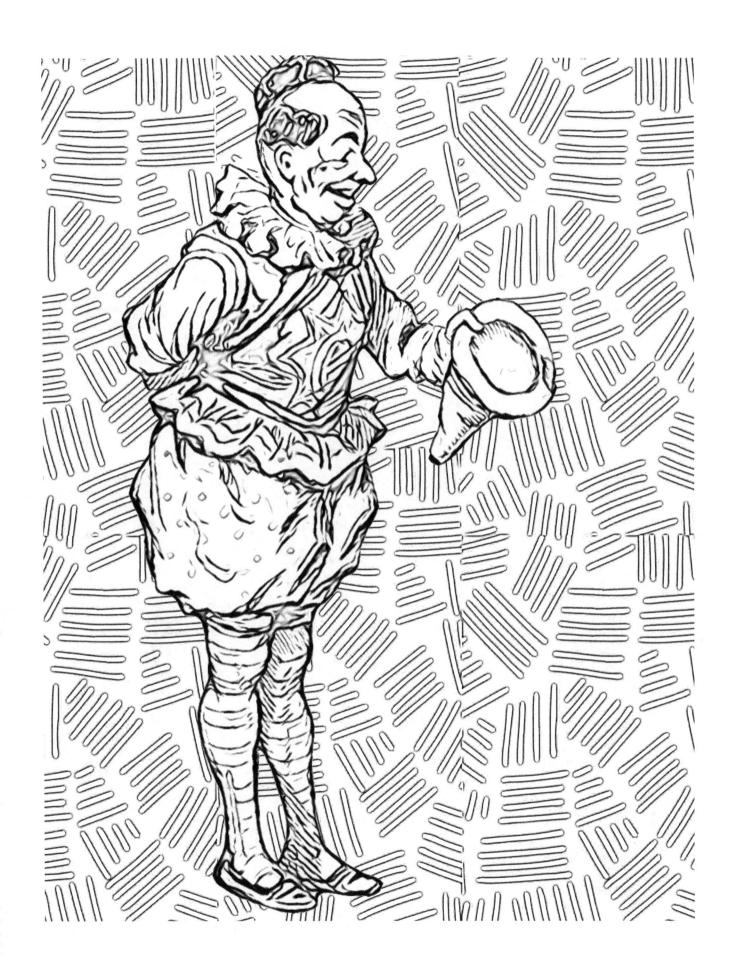

Also by Color me Vintage:

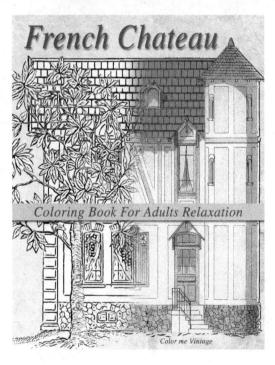

Join us @ Facebook Twitter Pinterest

•								